IMAGES
of America

LOST ELKMONT

Lost Elkmont author Daniel Paulin stands on the porch of the newly refurbished Appalachian Clubhouse. This photograph was taken on June 25, 2011, when the Great Smoky Mountains National Park hosted an open house for relatives of original Appalachian Club members and others with close ties to the Elkmont summer community. (Courtesy of Jack Williams.)

ON THE COVER: Men, women, and children enjoy the sights and sounds of the Great Smoky Mountains from their vantage points on the steps and landing below the Wonderland Club Hotel. This photograph most likely predates the establishment of Great Smoky Mountains National Park in 1934. The hotel was built in 1912 by Charles B. Carter and his two brothers after they obtained the land from Col. Wilson B. Townsend in 1911 with the stipulation that they would build a hotel on the site. It was an important addition to the rest of the Elkmont summer community. (Courtesy of the Great Smoky Mountains National Park Archives.)

IMAGES
of America
LOST ELKMONT

Daniel L. Paulin

ARCADIA
PUBLISHING

Copyright © 2015 by Daniel L. Paulin
ISBN 978-1-4671-1382-3

Published by Arcadia Publishing
Charleston, South Carolina

Printed in the United States of America

Library of Congress Control Number: 2014951476

For all general information, please contact Arcadia Publishing:
Telephone 843-853-2070
Fax 843-853-0044
E-mail sales@arcadiapublishing.com
For customer service and orders:
Toll-Free 1-888-313-2665

Visit us on the Internet at www.arcadiapublishing.com

This book is dedicated to my wife, Karen G. Rowe Paulin; our daughters, Sarah E. Paulin Meredith and Corey L. Paulin Botsford; and my much missed and beloved late mother, Elouise "Bo" Fischer Paulin. It was she who first introduced me to the wonders of Great Smoky Mountains National Park as a young boy and kindled my passion for history.

Contents

Acknowledgments		6
Introduction		7
1.	Before Elkmont	9
2.	The Coming of Commercial Logging	19
3.	The Appalachian Club	55
4.	The Wonderland Club	107
5.	Elkmont and Great Smoky Mountains National Park	119
6.	The Elkmont Historic District	123
Epilogue		126

Acknowledgments

This book could not have been undertaken and ultimately completed without the assistance of so many supportive and generous people who shared their time, knowledge, and encouragement in my attempt to tell the story of Elkmont.

I wish to thank, foremost, my wife, Karen, for her constant encouragement, never-ending ability to keep me focused, interventions to reinvigorate me when my enthusiasm waned, and herculean assistance in helping me research Elkmont.

Others deserving much credit include Mr. Shirley Teaster, the first local resident I met after moving from southern Indiana to Sevier County, Tennessee, in 2010. Born in Elkmont prior to the establishment of Great Smoky Mountains National Park, Teaster is a wealth of information about Elkmont's early mountain families. It is altogether fitting that I met Teaster at the dedication of the refurbished Appalachian Clubhouse in Elkmont on Saturday, June 25, 2011.

Herb Handly was an incredibly patient and invaluable mentor to me. A living historian on all things Elkmont, he shared his encyclopedic knowledge with me on numerous treks into Elkmont and over more lengthy breakfast conversations than I can count.

Carroll McMahan, a local author and historian, encouraged me to do this book. He constantly pushed me to attempt things that he had faith in my ability to deliver.

Thanks to Richard Atchley for his extraordinary generosity and technical assistance in the preparation of this book.

Heartfelt appreciation and gratitude is due for the professionalism and courtesy extended by Great Smoky Mountains National Park (GSMNP) staff, including park rangers Brad Free, Kent Cave, Bob Wightman, and Dana Soehn, GSMNP librarians Annette Hartigan and Michael Aday, chief archivist John McDade, and former GSMNP park archaeologist Erik Kreusch. Thanks also to Sally Pohlemus, Calvin M. McClung Historical Collection archivist, the University of Tennessee's Special Collections Unit, and local residents, including Darrell Huskey, Mary Thompson Headrick, Sandra P'Pool, Leslie Atchley, Rex Teaster, Freda Hermann, Ray Teaster, Janice Henderson, and Cathy Briscoe.

Unless otherwise noted, all photographs in this book were obtained from and appear courtesy of the Great Smoky Mountains National Park Archives.

My sincere apologies to anyone I may have failed to mention.

Introduction

The mountains are calling and I must go.

—John Muir

Why the title *Lost Elkmont*? Elkmont certainly can be found on all of the Great Smoky Mountains National Park maps. Elkmont itself is not lost, but much of its history is little known by anyone other than knowledgeable locals, park historical/cultural interpreters, curious history buffs, inquisitive visitors, and the descendants of the people who once lived there or toiled for the Little River Lumber Company or the Little River Railroad Company or inhabited the summer communities that developed there in the early 1900s.

Elkmont is located in the north-central part of the Tennessee section of Great Smoky Mountains National Park. This park also overlaps portions of North Carolina and is the most visited national park in the United States. The park receives between nine and 10 million visitors yearly and is within a one-day drive for 60 to 70 percent of the nation's population. However, only a fraction of those visitors are likely aware of the history and/or significance of Elkmont or realize that there is so much more to it than its present designation as one of the park's nine developed campgrounds and a jumping-off point for hiking.

As of the writing of this book in the spring and summer of 2014, many of the physical remnants of Elkmont's history not already removed by Great Smoky Mountains National Park are fast being erased by the passage of years, theft by souvenir hunters, and destruction by vandals. Despite the park staff's best efforts to protect, preserve, and rehabilitate the Elkmont Historic District, this battle against time awaits victory.

Elkmont was formerly a logging town, established around 1908 by Col. Wilson B. Townsend. A Pennsylvania businessman and entrepreneur, Townsend initially traveled to the southern Appalachians in 1898 in search of hardwood forests from which he could harvest timber to meet the need for construction materials in the northeastern United States, where rich forests had been depleted. Townsend indeed found what he had been looking for and, in short order, introduced modern-day commercial logging to an area that later became a part of Great Smoky Mountains National Park.

Townsend purchased approximately 86,000 acres in 1901 and quickly established the Little River Lumber Company and, shortly thereafter, the Little River Railroad Company. The railroad was the key to providing an efficient method of transporting the timber harvested in the mountains back to the large sawmill he built around 1903 in the community formerly referred to, at different times, as either Tuckaleechee Cove or Tang.

Shortly after Colonel Townsend's arrival in the area, the community was renamed Townsend in his honor. His logging and railroad operations provided hundreds of jobs to a mountain populace that was previously barely eking out a living, mostly as subsistence farmers, hunters, and gatherers. They seldom had, nor rarely saw, money prior to their employment with Townsend's lumber company or railroad.

The present-day Little River Road, also identified as Tennessee Highway 73 in Great Smoky Mountains National Park, connecting Elkmont to Townsend, actually sits atop the original railroad bed constructed by the Little River Railroad Company. Furthermore, the Elkmont Campground is located at the site of the former logging town.

Great Smoky Mountains National Park was established on June 15, 1934, and was officially dedicated by Pres. Franklin D. Roosevelt on September 2, 1940, at Newfound Gap, located on the Tennessee–North Carolina border.

One of this park's distinctions is that it was formed entirely by the purchase of privately owned land located in the states of Tennessee and North Carolina. Almost all of the other national parks were established on public lands owned by the US government.

Great Smoky Mountains National Park, located within the Appalachian mountain chain in the southeastern United States, contains roughly 521,000 acres of thickly forested mountains, peaceful valleys—"coves," as the local mountain residents call them—boulder-strewn rivers, bucolic and swiftly moving streams, waterfalls, awe-inspiring mountain vistas, and over 800 miles of trails in a federally protected wilderness sanctuary.

The park is known worldwide for its diversity of flora and fauna. Since 1973, the park has been designated an International Biosphere Reserve, and it was certified by the United Nations as a World Heritage Site Reserve in 1983.

Elkmont is a miniscule portion of the total landmass that makes up Great Smoky Mountains National Park. It is but one of many oases in the midst of spectacular beauty and wilderness. More important, it can serve as a map for those wishing to chart the progression of this area from early pioneer expansion to the exploitation of natural resources via commercial logging to the beginnings of an ecotourism economy that introduced wilderness lodging and unlimited recreational opportunities.

The term *Elkmont* dates to the early 1900s. The site was once a playground for adventuresome and mostly well-to-do Knoxville sportsmen who traveled to the area for its beauty and abundant fishing and hunting opportunities. This region was not, as many incorrectly assume, named for an abundant elk herd that once inhabited the area. There was, in fact, no such population of these majestic animals to be found in this location. It actually became known as Elkmont due to its being a recreational destination for members of the Knoxville Elks Club.

There are different theories as to how this community got its name, but one of the most frequently espoused explanations claims the area was originally called Elk Mountain by these Elks Club outdoorsmen and that, over time, the name was shortened to Elkmont.

The most interesting historical period of Elkmont, in this author's opinion, is that between 1900 and the establishment of Great Smoky Mountains National Park in 1934. This era saw logging give way first to the Elkmont summer communities and then to commercial tourism. For better or worse, the economies of the park's bordering towns remain almost totally dependent on this industry.

One

Before Elkmont

Individually and collectively, Cherokee people possess an extraordinary ability to face down adversity and continue moving.

—Wilma Mankiller

Historically, non-Native Americans are a recent addition to the area now known as Elkmont. European explorers are believed to have entered the Appalachians in the mid-1500s, probably north of present-day Great Smoky Mountains National Park. Before European American settlers came to east Tennessee in the 1800s, this land had been occupied for more than 10,000 years by various Native American tribes. Cherokee Indians were known to be present in the Elkmont area when records show the first white settlers started arriving in the area of Jake's Creek around 1830.

As Michael Ann Williams states in her book *Great Smoky Mountain Folklife*, at the time of the first European contact, Cherokee Indians inhabited not only the Smoky Mountains region of Tennessee and North Carolina but also 40,000 square miles of land extending into what are now Kentucky, Georgia, and Alabama. Comparatively, Great Smoky Mountains National Park encompasses slightly over 521,000 acres.

As the Europeans moved westward in the early 1800s, they brought with them diseases for which the Cherokees had no resistance. The ensuing encroachment by white settlers provided a glimpse of what was to become of the Cherokee Nation. The Cherokees relinquished the first of their land in the Smoky Mountains in 1791 and, by 1819, had lost most of their holdings in the mountains. Tennessean Andrew Jackson, elected president in 1828, advocated the removal of Native Americans to the west.

In 1830, Congress passed the Indian Removal Act. The Treaty of New Echota in 1835 ensured the loss of most Cherokee land in the eastern United States. A small settlement of "more traditional" Native Americans separated from the greater Cherokee Nation and became known as the Eastern Band of the Cherokee Nation. They farmed the lower elevations along the Oconoloftee River in North Carolina along with white settlers.

Most of the Cherokee Nation was relocated to Oklahoma in a forced migration orchestrated by the US government in 1838. Known as the Trail of Tears, this removal of the main Cherokee Nation ensured the influx of white settlers and changed the Smoky Mountains forever.

Andrew Jackson (1767–1845), the nation's seventh president, took office on March 4, 1829. Laws enacted during his term led to the removal of most of the Cherokee Nation from Tennessee and North Carolina in what is now Great Smoky Mountains National Park. (Library of Congress.)

This depiction of the forced removal of the Cherokee Indians from the Smoky Mountains area was painted by Robert Ottaker Lindneux. The exodus to Oklahoma became known as the Trail of Tears, as many Native Americans died along the way due to sickness and extreme weather conditions encountered on the long march. (Courtesy of the Woolaroc Museum.)

Drury P. Armstrong (1799–1856) was at one time one of the largest owners of property now included in Great Smoky Mountains National Park. He once owned 50,000 acres of the approximately 521,000 acres now included within the park's boundaries, including the land that later became known as Elkmont. (Courtesy of the Calvin M. McClung Historical Collection.)

This cabin was built around 1845 by Humphrey Ownby above Jakes Creek. The cabin and its 18.5 acres were purchased in 1918 by Frank and Mayna Treanor Avent. Mayna was a highly acclaimed Southern artist. It is one of the oldest preserved buildings in the park.

Sitting on the porch of their weathered home are Sarah Elizabeth Watson Ownby and her husband, Thomas David Ownby. Shortly after marrying, they moved to what was then referred to as the Little River community around 1870. The community later became Elkmont. (Courtesy of Carroll McMahan and Joan Parkinson.)

Sarah Watson gave birth to a son, Lemuel S. "Lem" Ownby, on February 24, 1889. He later lived in a cabin up Jakes Creek and was the last lifetime leaseholder to live inside Great Smoky Mountains National Park. Lem was 19 years old in 1908 when the Elkmont logging town was established. (Courtesy of Carroll McMahan.)

Levi Trentham (1852–1936) owned land along Jakes Creek and operated both a tub mill and sawmill. He was a genuine "mountain man" and a constant presence in the Elkmont community. Trentham married Thomas Ownby's sister, Lithia Emmaline Ownby.

This tub mill is believed to be one owned and built by Levi Trentham and already present on Jakes Creek when the logging town of Elkmont was established. If not Trentham's mill, this was certainly representative of the mills built along creeks during that time.

Flume leading to old Trentham mill- appalachian Club Elkmont Tenn

This is a water flume designed to direct water to one of Levi Trentham's mills. The water was sent down the chute to turn the turbine that powered the machinery inside the mill.

This photograph provides a close-up view of the fine craftsmanship required to build these old water-powered mills. The individual components, built by hand, provide impressive evidence of these early mountaineers' understanding of engineering.

A mountain man stands on a curly ash tree that served as a bridge over one of the many waterways in early Elkmont.

This is a much more sophisticated log bridge compared to the one pictured above. This bridge, believed to have been located in Elkmont, had a floor and sides with handrails.

In the 1800s and early 1900s, there were no automobiles or trucks and very few wagons with wooden spoke wheels, much less smooth roads. Most goods were transported on wooden sleds, usually pulled by a mule or horse. Here, a young mountain boy repairs such a sled.

Jakes Creek would have appeared much like this when the first European settlers built their homes here in the mid-1800s. The banks of all waterways in the Smoky Mountains were covered with virgin forests and all manner of lush flora. (Courtesy of Richard Atchley.)

Two

The Coming of Commercial Logging

No one should be able to enter a wilderness by mechanical means.

—Garrett Hardin

The harvesting of valuable hardwoods in the Little River drainages had been attempted on a small scale by the late 1800s, but it never proved commercially viable. Transporting the timber out of the mountains proved to be very difficult.

Early logging required those involved to snake felled trees down steep mountainsides with oxen or draft horses. And, once the trees were felled, there was still the matter of where and how to transport the logs out of the mountains. The few roads that existed were primitive at best.

Initially, massive splash dams, constructed of logs, were built to dam up the Little River, creating large pools where trees could be collected and held. These splash dams would then be dynamited, allowing the logs to ride the wave of water downriver. Due to floods and obstacles provided by boulders and fallen trees, this proved to be not only extremely labor intensive but also inefficient. All this was about to change, however.

By the late 1800s, much of the old-growth forest had been depleted in the northeastern United States, having been used in the building of farms, small towns, and large cities. This provided the impetus to locate new, rich forest lands where more hardwood trees could be cut and board feet of lumber milled.

Col. Wilson B. Townsend, a Pennsylvania entrepreneur, first visited the Great Smoky Mountains in 1898 and founded the Little River Company in 1900. He ultimately purchased approximately 86,000 acres in Blount and Sevier Counties in Tennessee, including much land along the Little River and its drainages, including the Jakes Creek area.

In 1901, construction began on his sawmill in Tang, later renamed Townsend in his honor. Prior to the mill becoming operational in March 1903, he founded the Little River Railroad Company and tied it into the Knoxville & Augusta Railroad in Walland, Tennessee. He extended his new railroad from there to Tuckaleechee Cove and Townsend. By 1908, his railroad expanded from Townsend through the Little River Gorge to the area now known as Elkmont. A logging town was established.

The Little River Lumber Company logged the Elkmont area through 1925. Townsend's railroad had succeeded in making wide-scale commercial logging in the mountains successful.

The Swaggerty and Eubanks Lumber Company attempted commercial logging near Elkmont around 1880. Pictured here is its mill on or near Blanket Mountain.

This is believed to be the remnants of a splash dam along the Little River. Early attempts to transport logs out of the mountains required that these dams, constructed out of logs, be built to create a pool of water into which logs could be deposited. Once the desired number of logs was accumulated, the splash dam would be dynamited, and the freed logs would ride the crest of water downstream.

Col. Wilson B. Townsend, the founder of the Little River Lumber Company, is pictured here in his younger years. He later built a large sawmill in Townsend, Tennessee. Colonel Townsend began construction of the Little River Railroad Company between 1901 and 1903. Large-scale logging was in its infant stages along the Little River watershed.

The man on the left is dwarfed by this tree. Such images of the massive trees to be found in the southern Appalachians had to be very exciting to Colonel Townsend and other owners of lumber companies, who soon purchased large tracts of land in these mountains.

Caroline Walker Shelton (far left) and her children pose in front of an enormous chestnut tree somewhere along the Little River watershed. Her children are, from left to right, John, Leona, Effie, and Hazel. Caroline's husband, Jim Shelton, was an amateur photographer who captured many interesting images during the span of the Little River Lumber Company operations. He was employed by the lumber company and its railroad. Mrs. Shelton was one of the famous Walker sisters, who lived out their lives in the Little Greenbrier area as lifetime leaseholders in the park. She was the only one of the sisters to marry.

LUMBER OPERATIONS PRIOR TO THE NATIONAL PARK

This map indicates the names of other lumber companies and the large tracts of land they purchased in the Smoky Mountains. They, like the Little River Lumber Company, became very proficient in logging the valuable hardwoods from the mountain slopes. By the time these companies completed operations, approximately 70 percent of the mountains had been logged. Their holdings were eventually purchased for the creation of the national park but not, in most cases, without considerable litigation.

Photographs like these, of men standing next to massive logs harvested from the mountains, had to quicken the pulse of lumber company executives and their stockholders. A solution to the problem of transporting logs out of the mountains had to be found for commercial logging to be successful. Colonel Townsend's Little River Railroad Company provided the answer. A massive undertaking, constructing the railroad took years. It was not until 1908 that the Little River Railroad reached the area soon to be named Elkmont from its headquarters in Townsend, Tennessee.

This is another photograph depicting the size of trees available for harvesting by the Little River Lumber Company. The man sitting here looks miniscule in comparison to the stump.

This railroad crew is digging the roadbed through the Little River Gorge between Townsend and Elkmont. The workers accomplished this task using only shovels, picks, and wheelbarrows.

In these photographs, crews building the railroad bed and laying down track pause for the camera. These men endured long days of backbreaking labor. Progress came slowly, but this effort was required to build the railroad so that trees could be cut and removed.

This crew carries heavy sections of railroad track to be secured by spikes into wooden railroad ties on the Little River Railroad Company's expansion to Elkmont. Jim Shelton is standing between the tracks in the right foreground of the photograph.

The excavation of the railroad right-of-way along the Little River gorge is being aided by a steam shovel around 1906. This machine resulted in greater volumes of rock and dirt being moved at a much faster pace than digging by hand.

These railroad tracks run along the Little River gorge between Townsend and Elkmont. This scene of tracks winding through the gorge is proof of the hard work expended by the workers who toiled here.

A young boy watches as four men saw a huge poplar tree. This is representative of the size of trees harvested by both the Little River Lumber Company and other logging companies operating in the mountains around the same time.

Another crew of four men is busy sawing a large tree with crosscut saws. These saws ranged between eight and 12 feet in length. The diameter of the trees determined the length of the saw to be used.

Sherman Myers snakes a log down a mountainside. He is ably assisted by a team of horses. Note the heavy chain connecting the log to the horses.

Several teams of men and horses drag massive logs down the hillside. The logs would be deposited at "landings" near the train tracks, later to be loaded on flatbed railroad cars.

George Shults (center foreground) and two other loggers lead a team of six oxen to remove logs from the forest. This photograph also illustrates the large chains used to connect the log and the oxen. Both man and beast labored mightily.

Wooden slides were also constructed along mountainsides. Felled trees were pulled down along these slides by horses or other teams of animals to the railroad tracks to be collected by the logging trains.

Seen here are an early cable skidder and a log loader. These machines are loading logs onto flatbed cars at one of many landings near Elkmont sometime between 1915 and 1920.

Little River Lumber Company's Clyde skidder No. 1 works on Jakes Creek around 1920. The machine pulls logs down and stacks them almost on top of the railroad tracks. Logging trains would alternate, going back and forth from location to location to retrieve the logs for their trip to the mill.

Clyde overhead skidder No. 5 sits idle on the tracks in the Three Forks area. Note the pile of logs waiting to be loaded from the mountainside around 1918.

The pushing track crew of Little River Shay engine No. 11 is pictured here with a Marion shovel. A skidder also appears behind and to the left of the train. This photograph was taken around 1916.

In this c. 1924 photograph, three men stand on top of a log ready to be placed by a log loader onto a flatbed train car. A worker is holding a peavey hook in his right hand. These hooks were designed to help move and turn logs. This scene was captured on Jakes Creek above Club Town, also known as Daisy Town.

34

Little River Shay engine No. 9, crossing a long wooden trestle, carries a log loader and a cargo of logs around 1923. This trestle was located in the Three Forks area of Elkmont.

A loader is seen here loading logs onto a flatbed railroad car.

Park officials, on a "Casey Car," inspect railroad and logging operations in Great Smoky Mountains National Park. Colonel Townsend had successfully negotiated the rights to continue logging for five years following the establishment of the park in 1934. At the front of the car is GSMNP park superintendent J. Ross Eakin.

LITTLE RIVER LUMBER COMPANY,
Manufacturers of all kinds of
HARDWOODS AND HEMLOCK.
TOWNSEND, TENNESSEE

W. B. TOWNSEND,
PRESIDENT

TO OUR EMPLOYEES:

This certificate is evidence of insurance in force upon your life under a Group Insurance Policy issued by the Ætna Life Insurance Company of Hartford, Connecticut, to the Little River Lumber Company. Our object in taking out this Group Policy is to enable you, regardless of age and physical condition, to obtain insurance at a cost much lower than you can obtain it individually.

In the event of your death at any time or place from any cause whatsoever, while in our employ during the continuance of this insurance, the amount of insurance then in force upon your life will be paid to your beneficiary. The Group contract provides that in case of total and permanent disability occurring before the age of sixty years, the full amount of the insurance in force upon your life will be payable to you in lieu of all other benefits provided under the Group Policy.

You are at liberty to name the beneficiary to whom you desire payment to be made under the policy, which beneficiary is subject to change at your signed request at any time as provided in the policy.

This insurance does not take the place of any payments provided for under any Workmen's Compensation Act, but is in addition thereto.

This arrangement with the Ætna Life Insurance Company has been made with a view towards relieving employees of at least one of the ever present anxieties of life during their connection with us, and we trust that both the motive of putting into effect this insurance on your life, and the means adopted in making the plan available will prove agreeable to you.

Yours very truly,

Townsend provided life insurance to all employees of his Little River Railroad Company. This is a letter sent to all employees about their company-provided benefits. The photograph of Townsend attached to the letter depicts how he looked at this time.

37

This is the Aetna insurance policy issued to all Little River Lumber Company employees. The policy had a face value of $1,000. Premiums for the policy were deducted from employees' pay.

Little River Lumber Co.

SPECIALISTS IN

Yellow Poplar
Red and White Oak
Chestnut
Soft Maple
Birch, and all
Mountain Hardwoods

DRY KILNS AND PLANING MILL

Manufacturing Plant:
TOWNSEND, TENN.

General Sales Office:
218 Franklin Bank Building
PHILADELPHIA, PA.

This advertisement for the Little River Lumber Company appeared in a lumber industry trade journal sometime after 1903.

This south-facing photograph of the Elkmont logging town was taken around 1910. The barnlike building with a large opening at upper left was the railroad company's machine shop.

The vegetable gardens of residents and employees of the Little River Lumber Company occupying homes along the railroad tracks are visible in this south-facing photograph of Elkmont, taken around 1918.

This is a north-facing view of Elkmont logging town and the logging yard, seen from the coaling dock. The machine shop (right) is where locomotives, train cars, and other equipment would be serviced or repaired.

The machine-shop crew for the Little River Railroad Company appears in this early photograph.

40

This is the Little River Railroad Company's yard at Elkmont. A train car full of coal sits in the lower left corner. The Elkmont Hotel is at right.

The Elkmont Hotel, seen here around 1920, consisted of only two rooms. It stood just feet from the railroad tracks.

The Little River Railroad Company's commissary and the Elkmont post office stood just several yards away from the railroad tracks. This is how each structure appeared around 1921.

Here, two men stand next to a train sitting idle on tracks in Elkmont. Behind the train, the coal dock loader is clearly visible.

The Little River Lumber Company's Shay engine No. 4 tilts precariously due to the collapse of this wooden bridge around 1904.

A swinging railroad bridge at the mouth of Meigs Creek spans the Little River. An incline car with an engine, commonly referred to as a "Sarry and Parker," had a drum on it with a coil of steel rope acting as a cable. The men would grab onto the rope and drag it to a large stump on top of the mountain. After it was tied around the stump, the engineer on the machine would start the drum rolling; by this process, the Sarry and Parker would be drawn up and down the incline bridge by the cable. Jim Shelton took this photograph around 1924.

This Little River Railroad Company train, on its way to Elkmont, passes through the Long Arm Cut along the Little River Gorge. This rocky cut is located between Metcalf Bottoms and Elkmont.

A train pulling flatbed cars full of logs approaches a railroad trestle on its way to the mill at Townsend.

This train, heavily laden with logs, is stopped while two crewmen appear to be walking toward the rear. The man in front is carrying what looks to be a large oil can. This photograph was taken around 1925.

These two sets of railroad tracks split to the right and left of the Fish Camp commissary near Elkmont. Both tracks continued up the mountains to reach forested slopes at higher elevations for more hardwood trees to harvest. One set of tracks went up to the area known as Fish Camp, while the other went to Three Forks.

This photograph displays the slash and other destruction caused by logging done in the area around the Fish Camp commissary.

This is another photograph that shows the slash resulting from logging operations. Nearly 70 percent of the present-day Great Smoky Mountains National Park would have appeared this way around 1934 following the cessation of logging. Visitors to the lushly forested slopes today probably have little understanding of how miraculously nature has rebounded.

A logging crew using a team of horses pulls a wooden sled, possibly containing tree bark. Bark was a profitable by-product of logging, as it was an essential ingredient in the processing of animal hides into leather at local tanneries.

These railroad tracks led to Walland, Tennessee. The Schlosser Leather Company established a tannery there in 1901. Its main source for bark came from trees being harvested along the Little River watershed. Little of the trees harvested by the Little River Lumber Company went to waste, and the sale of this bark further expanded the coffers of the company.

The Little River Railroad Company used a number of cars whose wheels were modified to allow the vehicles to be driven on the tracks. These vehicles were utilized in transporting railroad personnel between the mill in Townsend and logging sites throughout the mountains, as well as for inspecting ongoing operations. Joseph Murphy Sr., Little River Railroad superintendent, is pictured in this Model T inspection car sometime between 1905 and 1910.

Little River motor car No. 1 is another example of an automobile modified to run on the rails. This vehicle, seen here sometime between 1910 and 1920, served as a company rail bus.

The log pond and the Townsend sawmill appear in this photograph. The logs were left to float in the pond for a period of time before going into the mill. This allowed the bark to be more easily removed.

This is another view of the millpond in Townsend. Note the man standing near the logs in the water.

Joseph Murphy Sr. (lower left in photograph with dark clothing, dark hat, and holding what appears to be a clipboard) inspects and grades lumber at the Townsend mill.

Long poplar planks are being stacked by mill hands at the Townsend mill. An appreciation of the size of the planks can be gained by comparing them to the men standing next to them. The girth of the poplar trees that produced these boards had to be amazing.

Sam Henry stands before the final trainload of logs to be sent to the Townsend mill. This would have been sometime in 1938.

53

Three mill hands rest on some the last logs delivered to the Townsend mill. It was 1938, and the Little River Lumber Company's days of logging were drawing to a close. Colonel Townsend had deeded all of the Little River Lumber Company's holdings that would later be included in GSMNP to the Tennessee Park Commission in 1925 for $273,557, which amounted to about $3.58 an acre. Part of the purchase agreement allowed Little River Lumber Company to continue logging inside the park through 1938. While there is no consensus as to the exact number of board feet of lumber that Little River Lumber Company extracted from the mountainsides between 1901 and 1938, estimates range between 560 million and 2 billion board feet.

Marvin L. Tipton (left), D.H. "Doc" Tipton (center), and Joseph Murphy Sr. (right), all Little River Lumber Company or Little River Railroad management officials, stand next to what is purported to be the final log sent through the Townsend mill. The Little River Lumber Company ceased all operations in 1939.

Three

THE APPALACHIAN CLUB

As one who has often felt this need, and who has found refreshment in wild places, I attest to the recreational value of wilderness.

—George Aiken

The Little River Lumber Company completed construction of a large band mill in Townsend in 1903. By 1908, it had extended its Little River Railroad into what was to become the Elkmont logging community.

The mountainsides were soon clear-cut, and Colonel Townsend, ever the prescient businessman, came up with yet another profitable idea to repurpose these lands. His Little River Railroad had been offering excursions to the area for some time, introducing Knoxville sportsmen to the mountains, where fishing and hunting opportunities abounded.

Townsend initially provided these Elks Club members passage from Knoxville to Elkmont on a special open train car with brightly painted lettering identifying it as the Elkmont Express. A caboose and covered passenger car followed later.

In 1910, Townsend deeded approximately 50 acres to the Appalachian Club, comprised of Knoxville Elks Club members and successful businessmen. It was originally a sportsmen's club, but the wives soon joined in, and the club increasingly became a destination for social activities. Shortly thereafter, prominent citizens from other Tennessee cities sought membership in the club. Soon, cottages were being built near the Appalachian Clubhouse, the first building to be constructed on this acreage.

This clearly marked a transition from land once exploited for its natural resources to a site for early tourism. A seminal "get back to nature" motif was introduced. The area soon evolved into an exclusive summer community, with 17 cottages near the Appalachian Clubhouse in the section that became known as Club Town or Daisy Town.

By the 1930s, over 20 additional cabins and outbuildings had been constructed along Jakes Creek from Daisy Town, expanding to the area known as Society Hill. An impressive commercial orchard was also planted by property owner Rufus J. Hommel on the adjacent mountainside around 1917.

The final section of the Appalachian Club is referred to as Millionaire's Row. It was built along the Little River and consisted of nine cottages and associated outbuildings. All but three of these homes were owned by, and later leased to others by, Colonel Townsend's third wife and widow, Alice Morier Townsend. Her showplace home, "Happy Landings," burned to the ground in 1968.

Homes in and adjacent to the Alice Townsend tract in Millionaire's Row included cabins owned or leased by the Spence, Brandau, Parrott, Murphy, Cambier, Young, Faust, and Miller families.

Elks Club members ride the observation car to Elkmont. The Little River Lumber Company provided fares to these members sometime after 1908. Note the logs covering the hillsides that had not yet been transported to the mill in Townsend.

This is a round-trip ticket sold by the Little River Lumber Company for the Elkmont-to-Townsend run.

ELKMONT, the terminus of the Little River Railroad, is so located as to afford the fullest enjoyment to every lover of nature. Government trails connect it with lookout points where excellent panoramas and views of some of the loftiest peaks in the Eastern United States can be obtained.

MAP OF THE ELKMONT COUNTRY
Trails ---- Roads ==== Railroad ++++

MAP OF KNOXVILLE & AUGUSTA RAILROAD, LITTLE RIVER RAILROAD, TENNESSEE & CAROLINA SOUTHERN RAILWAY

CONDENSED TIME TABLE
Effective about June 1, 1915

SOUTHBOUND		Sunday Only	Daily Ex. Sun.	Daily	Sunday Only
		A. M.	A. M.	P. M.	A. M.
Lv. Knoxville	E	8:00	7:30	3:00	7:30
Lv. Maryville	L	8:35	8:15	3:45	8:15
Lv. Walland	K	9:05	8:50	4:35	8:50
Lv. Sunshine	M	9:15	9:03	4:48	9:03
Lv. Townsend	O	9:25	9:15	5:00	9:15
Lv. Line Springs	N	10:05	10:05	5:35
Lv. Wonderland Park	T	10:25	10:25	5:55
Lv. Elkmont	SPECIAL	10:27	10:27	6:02
Ar. Appalachian Club		10:30	10:30	6:05

NORTHBOUND		Sunday Only	Daily Ex. Sun.	Daily	Sunday Only
		P. M.	P. M.	A. M.	P. M.
Lv. Appalachian Club	E	6:00	2:30	7:15
Lv. Elkmont	L	6:02	2:37	7:17
Lv. Wonderland Park	K	6:05	2:40	7:20
Lv. Line Springs	M	6:25	3:05	7:40
Lv. Townsend	O	7:05	4:00	8:15	4:00
Lv. Sunshine	N	7:15	4:12	8:27	4:12
Lv. Walland	T	7:30	4:30	9:00	4:30
Lv. Maryville	SPECIAL	7:55	5:05	9:35	5:05
Ar. Knoxville		8:30	5:45	10:15	5:45

INFORMATION

Information in regard to schedules and connections will be furnished by ticket agents of connecting lines, or on request to

W. P. HOOD, Superintendent,
Knoxville & Augusta Railroad,
Knoxville, Tenn.

J. P. MURPHY, Superintendent,
Little River Railroad,
Townsend, Tenn.

CURRAN, ST. LOUIS

This page from a Little River Lumber Company brochure provides a map of the company's routes between Knoxville and Elkmont. Also included is a condensed timetable showing daily departure times for the Elkmont Special Excursion around 1915.

The Elkmont Special, loaded with Elks Club members, pauses while crossing a wooden trestle to allow a photograph to be taken. This picture of an open observation car predates the covered passenger car and caboose later provided to Elks Club members by the Little River Railroad Company for their excursions to Elkmont. It was taken around 1910 or later.

The Little River Lumber Company sold the Appalachian Club approximately 50 acres of land in 1910. The club soon constructed a clubhouse for its members. Here, the porch of the Appalachian Club is packed with Elks Club members possibly waiting to eat dinner. Note their formal attire. Levi Trentham, a local mountaineer, is the bearded man standing in the back, next to the man wearing a white shirt, suspenders, hat, and bow tie. The Appalachian Club was established in 1907.

This is the first page of a deed dated February 11, 1910, showing the transfer of land from the Little River Lumber Company to the Appalachian Club.

This was the card room in the Appalachian Clubhouse, built around 1910. The original clubhouse was lost to a fire in 1932. It was rebuilt in 1934 without the original structure's second story.

Passengers who were visiting the Appalachian Club or members staying in their cabins would arrive and depart from this railroad platform. The Little River Railroad made regular excursions here after 1910.

Here, two ladies stand on the Appalachian Club railroad platform, having just disembarked from a train or perhaps awaiting one. It was a steep uphill walk from the railroad platform to the Appalachian Clubhouse.

This wooden walkway crosses over a ravine to the porch of the original Appalachian Clubhouse. The path below the walkway leads to the Appalachian Club railroad platform.

61

This young woman, possibly just having walked up the hill from the Appalachian railroad platform, stands in front of the Appalachian Clubhouse.

Club members congregate on the steps of an unidentified building in the Daisy Town section of the Appalachian Club.

Elkmont Tenn. in the early 1920's

A. The first house William Parton, lived in 1917. Carl and Iota lived here in 1926 before Hayes was born.
B. Second house William Parton, lived in until 1928.
C. Carl and Iota lived here when Hayes Lyle was born 11-7-1926.
D. Jake's Creek Cemetery.
E. Appalachian Club Rail Road Station.
F. Appalachian Club Hotel.
G. Recreation and Ball Park.
H. New School where Ora Ownby, and Edward Parton, Attended.
I. Baptist Church.
J. Old School where Iota Parton, Attended.
K. Last house Robert Ownby, lived in at Elkmont.
L. Machine Shop.
M. Elkmont Hotel.
N. Elkmont General Store and Post Office.
O. Second house Carl and Iota lived in James Carl was born here 5-11-1925.
P. First house Carl and Iota lived in after they was married 7-5-1924.
Q. Robert Ownby, lived here when Carl and Iota was married in 7-5-1924.
R. Wonderland Park Hotel.
S. Wonderland Park Railroad Station.
T. Boy's Scout Camp.
U. This is where Robert Ownby, lived when he paid dog tax on Turk, 9-17-1920 and where we had Typhoid Fever.
V. Mitchel and aunt Polly Ownby, lived here in 1920
W. Hubert Parton, lived here. This is where Carl and Iota spent their first night togeather after they was married 7-5-1924.
X. Old Elkmont Cemetery.
Y. This is where they turned the train around they called this a "Y".
Z. Appalachian Club Swimming Pool.

Old road to Gatlinburg
County Roads
Foot Trails

Jake's Creek

1. Levi Trentham, lived here.
Bridge

Foot Bridge

2. Robert Trentham, lived here.
3. Robert Trenham's Grocery store here.
Ford the river here
East prong of Little River.
Little River Lumber Co. Rail R.
4. Joe Parton, built a Grocery store here in 1926 after the railroad was removed in 1925.
Slick Limb Branch
Road

This map provides a quick guide to the locations of buildings, waterways, and other points of interest to be found in Elkmont in the 1920s.

63

This map points out locations of interest to those wanting to understand how Elkmont evolved from 1850 to 1992. It also shows existing structures in Elkmont around 2009. (Courtesy of GSMNP, with notes provided by Herb Handly.)

This cabin, constructed from logs, is Cabin No. 1 in Daisy Town. It is the first house across the road from the Appalachian Club. It was built around 1910, and its early owners affectionately named it "Wild Rose." It is identified on the park's Elkmont Historic District map as the Sneed Cabin.

After Colonel Townsend sold land to the Appalachian Club and cabins were built, these brochures were distributed to entice people to come to Elkmont for recreation and lodging in a wilderness setting. Visitors soon became interested in joining the Appalachian Club in order to obtain membership and build homes in this exclusive summer community.

This man, most likely an Appalachian Club member, clowns around on a stump in the Daisy Town section of Elkmont. Perhaps it is his cabin under construction behind him. This construction most likely took place between 1910 and 1920.

These men are gathered around a freshwater spring located behind and below Cabins No. 3 and No. 5 in Daisy Town. Early cabin owners got their water from natural springs; it would be years before the Appalachian Club cottages had the infrastructure for water from a central source to be piped to each of the cabins.

This is the Frank Gilliland cabin, identified as Cabin No. 18, in the Society Hill section of Elkmont. This property was originally purchased from the Appalachian Club by A.T. and F.F. Dosser in 1919. They were grandparents to Mrs. Frank Gilliland (Elizabeth J.). This is a good example where Elkmont cabins frequently remained solely with the same family until the leases expired in 1992 or 2001. This cabin is slated for demolition, as is the one pictured below.

This photograph of the Arthur T. Thomas cabin, Cabin No. 19 along Society Hill, shows the back of of the dwelling as viewed from Jakes Creek. It sat just west of the Gilliland cabin.

This cabin stands on Society Hill. Owned by Arthur T. Thomas, it is No. 19 on the Elkmont Historic District maps. It is slated for demolition. It was nicknamed "Camp Comfort."

This is Cabin No. 20 on Society Hill. It was originally deeded to Everett Floyd, but the Forest Andrews family owned and/or leased this cabin from the early 1930s until the lease expired on December 31, 1992. This cabin was nicknamed "Walnut Lodge." It will not be preserved by the park.

This is the interior of Cabin No. 23 on Society Hill. Park records indicate the cabin was being leased to Katherine McDonald as of 1969, and it remained in her name until the lease expired on December 31, 1992. Its spacious room featured a beautiful stone fireplace. The interesting architecture includes walls designed with windows intersecting with the roof and a doorway leading to a large screened-in porch overlooking Jakes Creek. This structure is not slated for preservation.

This cabin, No. 24, on Society Hill, was being leased by William S. Arnett as of 1969. It featured a bay window and heavy metal grids over the windows to keep bears out. The cabin, overlooking Jakes Creek, will be demolished.

Cabin No. 26 was last indicated, as of 1976, as being leased by the Hutchins and Newman families, according to park records. As the sign above the entryway attests, its moniker was "Lafalittle." It stood on Society Hill with a wonderful view of Jakes Creek. The cabin will not be preserved.

The Ambrose Gaines family had the lease on Cabin No. 27 on Society Hill as of 1969. The large home had a full basement with a door leading to the rushing waters of Jakes Creek. It will be demolished by the park.

This house, No. 38, on Society Hill, is listed as the Byers/Chapman Cabin. The Chapman name comes from Col. David Chapman, who led the successful campaign to establish Great Smoky Mountains National Park. In appreciation of his efforts, the Department of the Interior awarded him this cabin. Fearing how this gift would look, Chapman transferred this cabin to his brother-in-law, Rufus Byers. This is the only structure of about 26 Appalachian Club cabins on Society Hill that will be preserved as part of the Elkmont Historic District.

This is the view of Jakes Creek from the last of the Appalachian Club cabins on Society Hill. It appears as Cabin No. 41 on the park's Elkmont Historic District maps. The McNabb family held the last lease on the property. The lease expired on December 31, 1992. (Author's collection.)

This vertical water tank and its horizontal steel replacement sit on top of a hill above the last of the Appalachian Club cabins along Jakes Creek. The concrete building between these tanks contained a chlorinator, designed to treat the water that was gravity-fed to the Elkmont cabins and ensure its safety. As of the fall of 2014, these structures were still standing. (Author's collection.)

Although not a member of the Appalachian Club, "Uncle" Lem Ownby owned a house along Jakes Creek, above the rest of the summer homes owned and/or leased by club members. Nearly blind his entire life, Ownby was a beekeeper who depended on his apple trees to provide pollen for his bees. A large number of his bee boxes are evident in this photograph. A constant parade of locals and park visitors frequented his home to purchase honey. (Courtesy of Sandra P'Pool.)

This is the home of "Uncle" Lem Ownby and his beloved wife, Jemima "Mimmie" Ownby, above Jakes Creek. Following Lem's death in 1984, at the age of 94, the home was demolished by the park. The structure, poorly built, was determined to have no significant historical value, despite Ownby being the last lifetime leaseholder in the park. (Courtesy of Sandra P'Pool.)

This is the original Appalachian Clubhouse, constructed around 1910. This structure burned to the ground in 1932 and was rebuilt in 1934. Its replacement did not include the second story, seen here with apartments and/or guestrooms. (Courtesy of Calvin M. McClung Historical Collection.)

This c. 1969 hand-drawn map of the Appalachian Club cabins includes the names of cabin owners and/or leaseholders.

74

The Appalachian Clubhouse is seen here around 1970. A sign posted in the parking lot in front of the building leaves no doubt that the area was for Appalachian Club members only.

This photograph shows what the Appalachian Clubhouse looked like around the time its lease expired on December 31, 1992.

75

This c. 1992 photograph offers a side view of the Appalachian Clubhouse.

This postcard shows how popular the Appalachian Club's swimming hole was with its members. The swimming hole was located along the Little River in the Millionaire's Row section of Elkmont. The club constructed a dam out of boulders and wood, creating a pool of water deep enough on one end that swimmers could dive off the rocky cliff seen here behind the swimmers. The pool, like the Appalachian Clubhouse, was strictly for the exclusive use of club members.

76

Appalachian Club families, seen in this 1914 photograph, attest to the popularity of the swimming hole. The location was heavily used all summer long.

This stone walkway was built as a sidewalk of sorts for Appalachian Club members to access the swimming hole. This popular gathering spot also had a beach for those not inclined to engage in aquatic activities and stone walls to sit on while observing the action.

Alice U. Morier Townsend (1883–1969) sits on the terrace overlooking the Little River behind the Spence Cabin, No. 42, on Millionaire's Row. Colonel Townsend's third wife, Alice was married to Townsend for only about two years before she was widowed. She owned six of the nine homes located in this section of the Appalachian Club community. (Courtesy of Freda Hermann.)

Alice Townsend's own home, called Happy Landings, no longer stands on Millionaire's Row. She died in 1969. The photographs on the following two pages feature additional views of this fairy-tale-like cottage. Local legend (unconfirmed) holds that Walt Disney or one of his representatives visited this home, and the cottage in *Snow White and the Seven Dwarfs* may have been modeled somewhat after it. The right wing of the Spence Cabin can be seen in the background behind and to the right of Happy Landings.

It can be debated whether Happy Landings or the Spence Cabin, also known as "River Lodge," was more impressive. Alice Townsend offered the Spence Cabin for lease.

Some referred to Happy Landings as "the Mansion." The house burned to the ground in 1968 after being struck by lightning. It was not rebuilt.

Alice Townsend is engaged in conversation with an unidentified man on the riverside terrace behind the Spence Cabin. This cabin sat along the Little River behind Townsend's Happy Landings.

This is the Spence Cabin on Millionaire's Row. Repainted to its original salmon color while being restored by GSMNP around 2010, this cabin is quite eye-catching as it sits along the banks of the Little River on Millionaire's Row. It is available through the park for day-use rental.

This is another view of the Spence Cabin. Shirley Spence and his family were fortunate to lease this rustic cabin for 30 years before it's lease expired at the end of 1992. Shirley Spence's father was Col. Carey F. Spence, a World War I war hero, former Knoxville postmaster, business owner, one-time president of the Appalachian Club, and one of the original property owners in Daisy Town. Shirley Spence's son, Fletcher, along with his family, were the last of the Spence family members to have the exclusive lease of River Lodge. This cabin is the lone structure to be preserved in Millionaire's Row under the park's plan for the Elkmont Historic District. The other seven cabins and the Murphy garage in this section of Elkmont are slated for removal.

The Henry Brandau Sr. cabin along Millionaire's Row also sat on the banks of the Little River just east of the Spence Cabin. It is Cabin No. 43 on the Elkmont Historic District's Existing Conditions map. Brandau, a Knoxville real estate executive, purchased land from the Little River Lumber Company and built this summer home. Herb Handly, a relative of the Brandau family, states that Henry Sr. was quite the outdoorsman and, along with others, helped introduce rainbow trout to the streams in the Smokies after the native brook trout were nearly decimated as a result of heavy logging and the deposition of silt into the mountain waterways. The Brandau lease was passed down to Henry's three children. His son, Henry "Skeet" Brandau, owner of a Knoxville insurance agency, was quite an accomplished fly fisherman on his own and was regarded by many of his peers to be, if not the best, certainly one of the finest fishermen in the area.

This stone fireplace/barbecue pit graces the patio on the west side terrace of the Brandau cabin. The rushing waters of the Little River could be reached by a quick jaunt down several stone steps below the cabin terrace. One can only speculate as to the number of freshly caught trout that were taken from the nearby waters and prepared over hot coals by several generations of skilled Brandau fishermen. The delicious aroma of grilled trout may be but one of the reasons that the windows facing the outside fire pit featured small log posts nailed vertically across them. Perhaps this was to prevent entry through these windows from bears who had been attracted by the wonderful smell. The stone fireplace and terrace overlooking the Little River can still be viewed today, although the cabin has nearly collapsed upon itself.

Visitors to the Joseph Murphy Cabin may have passed through this ornamental wooden structure on their way to the home's front porch. This cabin is currently in deplorable condition and will not be preserved. It also has a garage, which has almost completely collapsed. This is Cabin No. 45 on the park's Elkmont Historic District map of the cabins in Millionaire's Row.

This is the interior of the Joseph P. Murphy cabin as it appeared around 1930 when occupied by its original owners, the William H. Schuerman family. Schuerman, dean of the School of Engineering at Vanderbuilt University in Nashville, purchased the property from the Little River Lumber Company in 1928 and constructed the cabin to serve as the family's summer residence. Schuerman drowned in the Little River below this cabin in 1932. Following this tragedy, his heirs sold the property to Little River Railroad Company superintendent Joseph P. Murphy Sr. and his wife, Ivan Cochran Murphy. This dwelling is shown as Cabin No. 45 on the Elkmont Historic District's Existing Conditions map.

Surprisingly, Alice Townsend received permission from the GSMNP to have this cabin, No. 49 on the Elkmont Historic District's Existing Conditions map, built for her caretaker around 1936. This was allowed despite the GSMNP having been established two years earlier and this land having been deeded to the park along with Mrs. Townsend's other properties. This caretaker's cabin is now identified on park maps as the "Cambier Cabin." Nora Cambier, who was given the lease by Mrs. Townsend, was her niece.

This picture of the doorway above the porch of Cabin No. 49, also known as Alice Townsend's Caretaker's Cabin or the Cambier Cabin, features a bear-shaped wooden sign with the word "Bearwallow." The cabin did, after all, sit on the banks of Bearwallow Creek. This sign is no longer attached to the front of the house. Its whereabouts, like so many items that have been pilfered from these old Elkmont cottages remains unknown.

A picturesque stone bridge over Bearwallow Creek provided entry to the late attorney and philanthropist Lindsey Young's "Canyon Cottage," Cabin No. 48. It is the last cabin on Millionaire's Row, located south of the Cambier Cabin across Bearwallow Creek. Unfortunately, his cottage was not included within the composition of this photograph. The Cambier Cabin, however, can be seen in the background. (Author's collection.)

This is another photograph of the bridge to Lindsey Young's cottage. The span was more aesthetic than practical, as its width was insufficient to allow an automobile to cross and drive up to the cottage. (Author's collection.)

The charming, fairy-tale-like bridge is seen here from yet another angle. Even after all the other structures are removed from Millionaire's Row (the Spence Cabin being the sole exception), there are no plans by the park to remove this bridge. Stone walls, walkways, terraces, and chimneys will be left in their present locations. (Author's collection.)

A pathway from the stone bridge exiting Lindsey Young's cabin leads one through these rock walls to the Faust Cabin on Millionaire's Row. "Spring Cottage" was the nickname for the Faust Cabin, which appears on Elkmont maps as No. 47.

The Faust Cabin on Millionaire's Row stood alongside Bearwallow Creek. It was leased by Hugh and Lynn Faust from Alice Townsend. It is scheduled for demolition.

Visitors to Millionaire's Row might have passed through these stone columns while strolling to the Loye Miller Cabin. Miller, a widely respected former editor with the *Knoxville News Sentinel*, negotiated a long-term lease on this property with Alice Townsend. This cabin, No. 48 on park maps, stands along Bearwallow Creek.

Loye Miller's cabin was also called "Spindle Top." He and his family were fortunate to lease this cabin for over 40 years from Alice Townsend.

This is a view of Loye Miller's cabin from the banks of Bearwallow Creek. Alice Townsend originally had this structure built to serve as horse stables. The area above the stables was later finished out to serve as living quarters so as to provide her with rental income.

These are the stables built by Alice Townsend below the Loye Miller Cabin. There were numerous stalls for horses. Townsend kept horses here to rent to visitors. She hoped that this would provide additional income. The park later requested that Townsend remove the horses from the property.

People congregate at the Baptist church in Elkmont. This church stood in a field surrounded by a large meadow where schoolchildren frequently played. The school was situated nearby, with the surrounding fields used as a playground.

In this photograph of the Baptist church in Elkmont, the structure has a steeple. The steeple does not appear in many early photographs. This church once stood on property that now serves as part of the park's Elkmont Campground. It was later moved out of the park to the Valley View Baptist Church in nearby Wears Valley, where it is now named the "Elkmont Chapel."

This postcard shows a large commercial orchard planted in Elkmont by Rufus S. Hommel. The massive orchard occupied 100 acres of mountainside east of the Appalachian Club cottages on Society Hill.

This rustic cabin, although not a structure associated with the Appalachian Club, can be found above Jakes Creek. The cabin was purchased in 1918 by Frank and Mayna Treanor Avent from Steve and Eva Ownby. Mayna Avent, a highly acclaimed Southern artist, used this cabin as her summer studio until the 1940s. Her work appears in museums and universities. She was once commissioned by the Smithsonian Portrait Gallery to reproduce two historic portraits.

The Little River Lumber Company continued logging year-round in the Elkmont area until 1925. Even when Appalachian Club members were not using their summer homes, there was always activity in the logging community. Here, a train pauses in winter at Elkmont. Snow can be seen on the train and on the ground.

With logging came many train wrecks. Probably the most famous was the Daddy Bryson wreck, which occurred in Daisy Town on June 30, 1909. Engineer Gordon A. "Daddy" Bryson and his brakeman, Charles Jenkins, were killed in the accident. On July 5, 1909, Little River Railroad visitors saw firsthand the horrible wreckage.

Fourth of July visitors to Elkmont and curiosity seekers view the Daddy Bryson wreck on July 5, 1909.

The Elks and Rebekahs convene in Elkmont in all their finery around 1912.

Decoration Day at the Elkmont Cemetery drew quite a crowd. All of those shown here seem to be very formally attired. This tradition persists today for many families, who honor their loved ones at the newer Levi Trentham Cemetery near Daisy Town. Families still gather on the first Sunday of June, but they now dress much more casually.

Here, two couples stand above the cowcatcher at the front of engine No. 110. Many club members and guests posed on the front of locomotives to be photographed. Pictures such as this certainly provided an interesting keepsake of their visit to Elkmont.

Elkmont citizens stand in front of the local post office. This was a popular spot to hang out and hear the latest Elkmont news. Posters of some kind are tacked to the porch wall.

James Earl "Doc" Webb, a Knoxville druggist, was a frequent visitor to Elkmont. He is all smiles in this photograph as he leans against the oxen while cradling what could be a jar of moonshine. Webb later moved to St. Petersburg, Florida, around 1925, and founded Webb City, "the World's Most Unusual Drug Store." It covered at least seven city blocks and became a huge tourist attraction before going out of business in 1979. The identity of the man in the vest and bow tie is unknown.

A woman and two children are easily outnumbered by the 11 men gathered near the steps to the porch of the Elkmont post office. Doc Webb is standing furthest to the right on the second step and is sporting the dark suit and light-colored hat. The identities of the other people in the photograph are unknown.

Visitors aboard an "Elkmont Excursion" train sightsee along the Little River on their journey to Elkmont. At least eight passenger cars of this Little River Railroad train are visible in the photograph. Colonel Townsend's efforts to attract visitors to explore "the beautiful Elkmont Country" appear to be succeeding.

The Civilian Conservation Corps (CCC) erected many bridges throughout Great Smoky Mountains National Park from the early 1930s through the beginning of World War II. Here, a CCC crew builds a bridge over the Little River near Millionaire's Row in Elkmont.

102

The Civilian Conservation Corps followed this architectural schematic while building the bridge over the Little River in Elkmont.

As the railroad was extended farther into the mountains, its workers followed closely behind to log the trees. Small wooden homes, referred to as "set off houses," were continuously moved up and down the mountainsides by train, allowing workers to live near the areas being logged. Here, a couple stands in front of their set off home with what appears to be a comfortable-looking leather chair.

A man stands with his wife and children and four other men in front of another set off house. When a number of these houses were placed end to end along a section of railroad tracks, it was referred to as a "stringtown." Many of the lumber companies logging the Smoky Mountains provided this housing for their employees, deducting the rent from their earnings.

This is the view through the door of Sam Cook's cabin while logging was underway above Jakes Creek. A stringtown and skidder can be seen in the top third of this photograph.

Not everyone who lived in or near Elkmont in the early 1900s was an affluent citizen from Knoxville or other large cities. William Council "Pap" Teaster and his wife, Tilda Jane Hicks "Mammy" Teaster, lived and raised a large family in this house on Bearwallow Creek near Elkmont. The house was built by Charlie and Eas Trentham in 1927. The Teasters had to vacate their home in 1938 following the establishment of Great Smoky Mountains National Park. They moved to a house on Happy Hollow Road in Wears Valley. (Courtesy of Mary Thompson Headrick.)

Mammy and Pap Teaster are pictured here in their later years. (Courtesy of Mary Thompson Headrick.)

105

Members of the Teaster family pose in front of the steps to their home on Bearwallow Creek in Elkmont. Shown here are, from left to right, (front) Monroe and Rance; (back) Bruce and Oliver (holding Verl). (Courtesy of Mary Thompson Headrick.)

Mammy and Pap Teaster's daughters Iva (left) and Lou (right) enjoy a nice day sitting in the sun on boulders in the Little River near Elkmont. (Courtesy of Mary Thompson Headrick.)

Four

The Wonderland Club

There is no harm in repeating a good thing.

—Plato

Following Col. W.B. Townsend's deeding of approximately 50 acres to the Appalachian Club in 1910, he deeded 65 acres to Charles B. Carter and his two brothers on a hillside above Elkmont overlooking the Little River in 1911. This transaction was conditional upon the brothers building a hotel there within a year.

The Carters did construct and open the Wonderland Park Hotel on June 11, 1912. It was open to the general public until 1915, when the Carters sold the hotel and adjacent properties to a group of Knoxville businessmen who had been rebuffed in their earlier attempts to join the Appalachian Club. This change of ownership resulted in a private club with its own exclusive membership rights named the Wonderland Club. Members also built a number of cottages on the tract.

An annex was built next to the hotel in 1920, and a large rear wing and side extension were added to Wonderland Club Hotel in 1928.

The Little River Railroad delivered to and collected club members and guests from a railroad platform adjacent to the railroad tracks below the hotel through 1925. After climbing a good number of stone steps and passing a fountain, visitors were welcomed by a wide wooden porch lined with rocking chairs fronting the hotel's double entrance doors. From this vantage point, they were rewarded with magnificent views of Blanket Mountain in the distance and the scenic Little River in the foreground.

The Wonderland Club deeded the property to the Tennessee Park Commission in the early 1930s, retaining a lifetime lease on the hotel and cottages. The state subsequently transferred the deeded property to the federal government for its inclusion into Great Smoky Mountains National Park.

The once-stately Wonderland Hotel was damaged by fire in 1995, collapsed in 2005, and was demolished in 2006. Although greatly deteriorated, most of the hotel annex and the remains of nine or so cottages were still standing in September 2014. These are all slated for demolition under the park's current plans for the Historic Elkmont District. All of these buildings provide numerous hazards and are quite unsafe. Entering them is prohibited by Great Smoky Mountains National Park; those who choose to disregard the "No trespassing" signs subject themselves not only to serious injury but also a substantial fine.

The first stop for railroad travelers entering Elkmont was the Wonderland Park Hotel railroad platform. Passengers, luggage, and all kinds of goods would be deposited here by way of the Little River Railroad.

A train is stopped below the hill where the Wonderland Park Hotel stood. The structure on the right was where passengers disembarked. They then traversed a long series of stone steps to reach the hotel. Many an enterprising young lad earned money carrying luggage up the steps to the hotel for guests.

These men appear to be waiting on the Wonderland Park Hotel railroad platform for the next train. Some of the men appear to be wearing military uniforms. This photograph was most likely taken during World War I, and the men may be visiting Elkmont while on leave. The wooden handrail at far left is at the base of the stone steps leading up the hill to the Wonderland Park Hotel.

This scene appears to be the work of a professional photographer, who had models pose at the base of the stone steps leading from the Wonderland Park Hotel. This image may have been used for advertising purposes. This photograph and the one that follows on page 111 must have been taken sometime after 1926, as the railroad tracks have been removed and replaced with a road. Colonel Townsend had the railroad tracks taken out to be used by the Little River Railroad in the Tremont area (formerly known as Walker Valley) of the present-day Great Smoky Mountains National Park. Luckily, Austin Peay, then governor of Tennessee, who also had a cabin in Wonderland Acres, saw that a gravel road was subsequently built over the railroad bed for access in and out of Elkmont.

This photograph also appears to be the work of a professional photographer. It was most likely taken at the same time as the previous photograph. The same models appear in both scenes. Here, the men, women, and children are posed at the top of the stone steps just below the Wonderland Park Hotel. Blanket Mountain can be seen in the background.

These four women are photographed sitting at a table on the porch of the Wonderland Park Hotel. They do not appear overjoyed to be having their photograph taken. (Courtesy of Calvin M. McClung Historical Collection.)

This is the pathway from the top of the stone steps leading the rest of the way to the Wonderland Park Hotel. The round stone structure in the foreground was a fountain that provided its own water show to entertain children and adults alike.

This is a nice view of the Wonderland Park Hotel. Visitors were greeted by a long covered porch and rocking chairs. Electric ceiling fans were later hung from the porch ceiling to provide a breeze on hot and humid days.

This is another view of the Wonderland Park Hotel. To the left of the picture stood the Wonderland Park Hotel Annex.

Members of the Appalachian Club community, a mile down the road, gathered in 1912 to check out the newly opened Wonderland Park Hotel.

People assembled along the front porch and children gathered around the fountain with its stream of water shooting upward is evidence of what an enchanting and popular place the Wonderland Park Hotel must have been. This photograph was taken around 1912.

The Wonderland Park Hotel Annex is shown here. It was built in 1920 to meet the Wonderland Club members' desire for additional privacy. It contained 29 rooms, as opposed to the 27 rooms in the Wonderland Park Hotel.

This is a commercial postcard that was used to advertise the Wonderland Club Hotel. The men pitching horseshoes are on a hill below the hotel annex. A portion of the Wonderland Club Hotel can be seen to the right of the annex. The buildings were connected with a covered porch. (Courtesy of Darrell Huskey, who managed the Wonderland Hotel from the 1970s until it closed forever on December 31, 1992.)

Approximately 10 cabins were built on lots comprising the rest of the 65 acres originally sold to Charles B. Carter by Colonel Townsend in 1911. This acreage was subdivided into 1,000 or so lots, but the cabins did not proliferate here as the ones in the Appalachian Club section one mile to the south did. Many of the lots were unfit for building on and went unsold. Many lots were given out in a number of questionable promotions but were never developed. The lots were mostly worthless.

This photograph of the Wonderland Club Hotel shows fallen leaves and a pile of inner tubes on the lawn. The tubes were used for floating in the Little River below the hotel. This photograph was taken about three weeks before the hotel closed its doors forever on November 15, 1992. The hotel was partially lost to fire in 1995, and it collapsed in 2005. The remnants of the hotel were removed by the park in 2006. (Courtesy of Leslie Atchley.)

The concrete steps and remains of a brick fireplace provide the only evidence of the once stately and bustling Wonderland Club Hotel. Its inviting porch and rocking chairs now exist only in memory. (Author's collection.)

Five

Elkmont and Great Smoky Mountains National Park

Wilderness is not luxury but a necessity of the human spirit.

—Edward Abbey

The origins of a preservation movement to protect lands in the Smoky Mountains region can be traced to the late 1800s. Concerned citizens initially were convinced that acquisition of these lands could only be accomplished by the federal government through eminent domain. The early campaigns to save the mountains would repeatedly catch fire only to be reduced to cooling embers.

Much of the credit for the successful effort to establish a new national park in the eastern United States goes to Ann Davis, her husband, Willis P. Davis, and Col. David Chapman. All three were early visitors to and guests of the Appalachian Club. After Ann Davis questioned why a national park could not be established in the Great Smokies, her husband reignited preservation efforts. Chapman unfalteringly and successfully led the movement, resulting in the establishment of the national park.

The belief that economic development of this impoverished area would accompany the development of a national park most likely proved as important in selling the idea as the plea for the conservation of the mountains before the lumber companies left them irrevocably ravaged.

While June 15, 1934, is widely recognized as the date that Great Smoky Mountains National Park was established, Pres. Calvin Coolidge had authorized the acquisition of land for the park in 1926. The majority of the land was acquired within five years, but not without the gargantuan efforts of Chapman and the Tennessee and North Carolina Park Commissions. The process was frequently controversial, complicated by competing political interests and personalities as well as prolonged negotiations with numerous lumber companies and landowners. The displacement of mountain families by eminent domain also drew criticism.

Even though most Elkmont property owners supported the establishment of a national park, others opposed it, preferring that the area be constituted as a national forest. The national park option was ultimately chosen, but acquiring the Elkmont property proved problematic.

Despite an act of Congress exempting Elkmont from eminent domain, the property owners eventually did deed their homes and property to the Tennessee Park Commission by 1932 in exchange for receiving half their appraised values and retention of life estates, which, in many cases, were not to expire until the death of the youngest member of the owner's immediate family.

Col. David Chapman was able to arrange for the members of the Tennessee Legislature to assemble at the Appalachian Clubhouse in Elkmont, where he could showcase the beauty and wilderness of the Great Smoky Mountains. This junket provided him with a captive audience to lobby for financial support to assist him in purchasing land for the proposed Great Smoky Mountains National Park. This picture obviously was taken before 1932, as it shows the original Appalachian Clubhouse, which was destroyed by fire that year and wasn't rebuilt until 1934. The long elevated wooden walkway that led uphill from the Appalachian Club's railroad platform is nicely pictured here, as is the second story of the original clubhouse. The rebuilt version did not include a second story.

National park proponent Col. David Chapman (second from left in the front row, standing just inside the railroad tracks) stops at Elkmont with a trainload of dignitaries. His object was both to entertain them and to give them an up-close look of the Smoky Mountains. (Courtesy of the Calvin M. McClung Historical Collection.)

David Chapman (third from left in the front row) and other proponents of the establishment of the national park are pictured here following the receipt of a $5-million gift from John D. Rockefeller. This donation, given in honor of his late mother, Laura Spellman Rockefeller, enabled the Tennessee and North Carolina Park Commissions to acquire additional land necessary for Great Smoky Mountains National Park. A monument was erected in Laura Rockefeller's honor at Newfound Gap between Tennessee and North Carolina.

"Here in the Great Smokies, we have come together to dedicate these mountains, streams and forests, to the service of the millions of American people. . . . There are trees here that have stood before our forefathers ever came to this continent." Pres. Franklin D. Roosevelt spoke these words in dedicating Great Smoky Mountains National Park on Labor Day, September 2, 1940, at Newfound Gap. Pearl Harbor was bombed 15 months later by the Japanese, on December 7, 1941, resulting in the United States entering World War II. Elkmont fathers and sons would serve in World War II in defense of this great nation just as other Elkmont men had in World War I.

Six

The Elkmont Historic District

Don't it always seem to go, that you don't know what you've got till it's gone.

—Joni Mitchell

The Appalachian Club and Wonderland Club summer communities in Elkmont continued to be occupied and enjoyed by their members and guests following the establishment of Great Smoky Mountains National Park in 1934. Most casual observers would notice little change since the properties had been deeded to the park.

In 1952, all but three or four Elkmont owners/lessees exchanged their lifetime leases for 20-year leases. This was done with the approval of the secretary of the interior so that electrical service could be provided to the remaining Elkmont lessees. The extension of leases through 1972 was necessary to insure the utility could recoup its expenses. The 20-year leases contained specific language stating the leases would not be extended past 1972.

Elkmont members established the Elkmont Preservation Committee prior to 1972 to lobby for another extension of the leases. Their efforts succeeded, and the leases were extended to 1992. Again, the lease agreements explicitly stated that there would be no further extensions.

In 1982, the park issued its General Management Plan, which called for the demolition of all structures in the Elkmont summer communities once the current leases expired. This was to allow the area to revert back to nature, in accordance with the park's designation as a wilderness area.

This prompted the Elkmont Preservation Committee to lobby for yet another lease extension. The park held firm this time, and the last of the 20-year leases expired on December 31, 1992. There remained the few cottage owners that had chosen to retain their original lifetime leases rather than convert to 20-year leases. The last of these lifetime leases expired on December 31, 2001.

Before the park could demolish the vacated cabins, a former cabin owner, Eleanor Dickinson, succeeded in getting most of the cabins placed in the National Register of Historic Places in 1994. Of the 74 structures, 49 were determined to have historical significance.

Contentious public hearings followed for a number of years, with numerous studies being contracted. This resulted in a No Action Plan and six proposals (A through F) being considered. Alternate C, which included the preservation of the Appalachian Club and 18 contributing structures establishing the Elkmont Historic District, ultimately became the agreed-upon course of action.

The Appalachian Clubhouse in the Daisy Town section of the Elkmont Historic District is shown here around 2009. Construction was just getting under way to refurbish this important anchor of the Elkmont summer community when this photograph was taken. Construction was completed, and an open house was held on Saturday, June 25, 2011, for persons with family ties to Elkmont. On Sunday, June 26, 2011, a second open house was held, open to the general public, allowing visitors to see the newly renovated structure.

The only other building thus far refurbished as part of the Elkmont Historic District is the Spence Cabin. Renovations had already been started at the time of this photograph, in 2009 or 2010. After completion of all cosmetic and structural repairs, this cabin was reopened for day use in 2011. It and the Appalachian Clubhouse are fine examples of what can be accomplished to preserve historic structures when funding can be found.

Epilogue

What a country chooses to save is what a country chooses to say about itself.

—Mollie Beattie

Great Smoky Mountains National Park is the nation's most-visited national park, receiving between nine and 10 million visitors annually.

Park visitors can thank the citizens of Tennessee and North Carolina, who helped collect pennies, nickels, dimes, and dollars over 80 years ago, and John D. Rockefeller, who donated $5 million in honor of his late mother, Laura Spellman Rockefeller, so that land could be purchased to establish this park. Their generosity resulted in all visitors entering the park paying nothing to do so.

Countless residents had to leave their farms and homesteads, and lumber companies had to relinquish their holdings, in order for the park to become a reality. Founding park supporters had to negotiate the purchase of over 6,000 parcels of land spread over Tennessee and North Carolina so the park could be established in 1934.

The park is just one of a handful of national parks that does not charge an entrance fee. Although an unexpected surprise for many visitors, this policy means that no additional dollars based on paid admissions are raised to help the park meet its needs. This provides many challenges for the park staff to keep up with infrastructure needs and visitor services. The National Parks Conservation Association (NPCA) recently estimated the amount needed to bring the entire national park system's already existing infrastructure, including roads and visitor services, to today's standards may exceed $9 billion. This does not include new buildings, programs, or infrastructure.

Federal budgets are what they are, and despite the American public's almost unanimous expression of love for the national park system, the parks continue to be grossly underfunded and are in constant danger of being "loved to death" by millions of visitors, domestic and foreign.

The NPCA's Center for Park Research issued a report in April 2004 highlighting major areas of concern confronting Great Smoky Mountains National Park. Among the five areas enumerated in the report, the following two stand out: the deterioration of historic structures due to insufficient maintenance and inadequate funding and staffing. The report also noted that the GSMNP had an annual budget of $11.5 million, which was at least one third short of its needed funding. The park also had a maintenance backlog in excess of $150 million. This was 10 years ago.

Without the financial support of nonprofit park partners, the Great Smoky Mountains Association, and the Friends of the Smokies—who together provided about $3 million in assistance for the current fiscal year—the GSMNP would fare much worse.

Many of Elkmont's Appalachian Club founding members and their guests played crucial rolls in the establishment of Great Smoky Mountains National Park. A number of buildings in the Elkmont summer communities were placed in the National Register of Historic Places in 1994. The district was placed on the "11 Most Endangered Places" list by the National Trust for Historical

Preservation in 2006. Since then, the Appalachian Clubhouse and the Spence Cabin alone have been fully refurbished. In addition, 17 or so other buildings designated to be protected, preserved, and rehabilitated as part of the park's Elkmont Historic District have been stabilized, but they continue to await funding so that they can be fully restored.

The GSMNP staff is clearly very dedicated and sincerely treasures the park. Its historic preservation crew employs a staff of only three full-time and three part-time/seasonal staff, yet currently there are approximately 113 historic structures in the park to be maintained. All the while, the effects of time, natural processes, unconscionable thieves, and thoughtless vandals continue to rob visitors of countless historic treasures and artifacts throughout Elkmont and the rest of the park.

The situation that confronts Elkmont is one of great complexity. The park has so many other ongoing maintenance needs necessary just to provide for the safety of visitors and to protect the park's many resources. Prioritizing limited budget dollars and making tough decisions is a struggle confronting all park administrations.

Perhaps the solution to acquiring the necessary funding to preserve the park and to inform visitors about Elkmont's historical significance and the contributions its members made to the formation of the GSMNP may involve not only the federal government but also solicitation of contributions from private donors, as was done in the 1930s. It is pretty much a sure bet that the federal budget will unlikely be able to provide the money needed to rehabilitate Elkmont in the near future, much less fund the well-documented unmet needs of all our national parks.

Anyone interested in donating their time, talents, or financial contributions to the park's vision for the Elkmont Historic District should contact the superintendent of Great Smoky Mountains National Park or this author to help insure that *Elkmont* truly does not become *Lost*.

Discover Thousands of Local History Books Featuring Millions of Vintage Images

Arcadia Publishing, the leading local history publisher in the United States, is committed to making history accessible and meaningful through publishing books that celebrate and preserve the heritage of America's people and places.

Find more books like this at
www.arcadiapublishing.com

Search for your hometown history, your old stomping grounds, and even your favorite sports team.

Consistent with our mission to preserve history on a local level, this book was printed in South Carolina on American-made paper and manufactured entirely in the United States. Products carrying the accredited Forest Stewardship Council (FSC) label are printed on 100 percent FSC-certified paper.

MADE IN THE USA